BISMI ALLAHI ARRAHMANI

In the name of Allah, the Gracious, the Merciful

This book belongs to:

TITLE OF SURA IN ARABIC

TITLE'S TRANSLITERATION ARABIC TO ENGLISH

TITLE'S TRANSLATION IN ENGLISH

SURA IN ARABIC

سُورَةُ الكَوْثَرِ

AL-KAWTHAR

PLENTY

بِسْمِ اللهِ الرَّحْمَنِ الرَّحِيمِ

إِنَّا أَعْطَيْنَاكَ الْكَوْثَرَ ①

فَصَلِّ لِرَبِّكَ وَانْحَرْ ②

إِنَّ شَانِئَكَ هُوَ الْأَبْتَرُ ③

7

SURA'S TRANSLITERATION ARABIC TO ENGLISH

SURA'S TRANSLATION IN ENGLISH

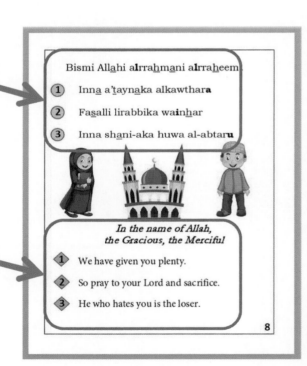

Bismi Allahi alrrahmani alrraheem

① Inna a'taynaka alkawthara

② Fasalli lirabbika wainhar

③ Inna shani-aka huwa al-abtaru

In the name of Allah,
the Gracious, the Merciful

① We have given you plenty.

② So pray to your Lord and sacrifice.

③ He who hates you is the loser.

8

TABLE OF CONTENT

TRANSLITERATION TABLE

Bold letters are silent.

"-" is to make some words easier to read

a : about / <u>a</u> : c<u>a</u>t

« ' » say "a" twice distinctly with an open mouth

b : **b**ox / **d** : **d**oor

<u>d</u> : **heavy "d" sound** (open jaw but keep lips slightly round)

ee : f**ee**t / **f** : **f**ish

gh : the sound you make when gargling (touch very back of tongue to very back of mouth)

h: **h**at

<u>h</u>: **heavy "h" sound** (drop back of tongue to open back of throat, then force air out for "h")

i : **i**nk / **j** : **j**ar / **k** : **k**it

kh : gravely "h" sound (touch back of tongue to roof of mouth and force air out)

l : **l**ook / **m** : **m**an / **n** : **n**urse / **oo**: p**oo**l / **o** : **o**n

q: "k" sound made in back of throat

r : **r**abbit (similar to Spanish "r")

sh: **sh**ip / **s** : **s**ea

<u>s</u>: **heavy "s" sound** (open jaw bat keep lips slightly round)

t : **t**an

<u>t</u>: **heavy "t" sound** (open jaw bat keep lips slightly round)

th: **th**ink / <u>**th**</u>: **th**ere

<u>*th*</u> : **"th" sound as in "there", but heavier** (open jaw bat keep lips slightly round)

u: **p**ut / **w** : **w**ater / **y**: **y**am / **z**: **z**ebra

سُورَةُ الفَاتِحَةِ

AL FATIHAH

THE OPENING

1 بِسْمِ ٱللَّهِ ٱلرَّحْمَٰنِ ٱلرَّحِيمِ

2 ٱلْحَمْدُ لِلَّهِ رَبِّ ٱلْعَٰلَمِينَ

4 مَٰلِكِ يَوْمِ ٱلدِّينِ **3** ٱلرَّحْمَٰنِ ٱلرَّحِيمِ

5 أَهْدِنَا إِيَّاكَ نَعْبُدُ وَإِيَّاكَ نَسْتَعِينُ

6 صِرَٰطَ ٱلَّذِينَ أَنْعَمْتَ ٱلصِّرَٰطَ ٱلْمُسْتَقِيمَ

عَلَيْهِمْ غَيْرِ ٱلْمَغْضُوبِ عَلَيْهِمْ

7 وَلَا ٱلضَّآلِّينَ

1. Bismi Allahi alrrahmani alrraheemi

2. Alhamdu lillahi rabbi al'alameena

3. Alrrahmani alrraheemi

4. Maliki yawmi alddeeni

5. Iyyaka na'budu wa-iyyaka nasta'eenu

6. Ihdina alssirata almustaqeema

7. Sirata allatheena an'amta 'alayhim ghayri almaghdoobi 'alayhim wala alddalleena

1. _In the name of Allah, the Gracious, the Merciful_

2. Praise be to Allah, Lord of the Worlds.

3. The Most Gracious, the Most Merciful.

4. Master of the Day of Judgment.

5. It is You we worship, and upon You we call for help.

6. Guide us to the straight path.

7. The path of those You have blessed, not of those against whom there is anger, nor of those who are misguided.

سُورَةُ الكَوثَرِ

AL-KAWTHAR

PLENTY

بِسْمِ اللهِ الرَّحْمَنِ الرَّحِيمِ

إِنَّا أَعطَينَاكَ ٱلكَوثَرَ ۝١

فَصَلِّ لِرَبِّكَ وَٱنحَر ۝٢

إِنَّ شَانِئَكَ هُوَ ٱلأَبتَرُ ۝٣

Bismi Allahi alrrahmani alrraheemi

1 Inna a'taynaka alkawthara

2 Fasalli lirabbika wainhar

3 Inna shani-aka huwa al-abtaru

In the name of Allah,
the Gracious, the Merciful

1 We have given you plenty.

2 So pray to your Lord and sacrifice.

3 He who hates you is the loser.

سُورَةُ الإِخْلَاصِ

AL-IKHLAS
MONOTHEISM

بِسْمِ اللَّهِ الرَّحْمَٰنِ الرَّحِيمِ

1 قُلْ هُوَ اللَّهُ أَحَدٌ

2 اللَّهُ الصَّمَدُ

3 لَمْ يَلِدْ وَلَمْ يُولَدْ

4 وَلَمْ يَكُنْ لَهُ كُفُوًا أَحَدٌ

Bismi Allahi a**l**ra**h**m**a**ni a**l**rra**h**eem**i**

(1) Qul huwa All**a**hu a**h**ad**un**

(2) All**a**hu a**ss**amad**u**

(3) Lam yalid walam yoolad**u**

(4) Walam yakun lahu kufuwan a**h**ad**un**

In the name of Allah,
the Gracious, the Merciful

1 Say, "He is Allah, the One.

2 Allah, the Absolute.

3 He begets not, nor was He begotten.

4 And there is nothing comparable to Him."

10

سُورَةُ النَّاسِ

AN-NAS

MANKIND

بِسْمِ ٱللَّهِ ٱلرَّحْمَٰنِ ٱلرَّحِيمِ

قُلْ أَعُوذُ بِرَبِّ ٱلنَّاسِ ﴿1﴾ مَلِكِ ٱلنَّاسِ ﴿2﴾

إِلَٰهِ ٱلنَّاسِ ﴿3﴾ مِن شَرِّ ٱلْوَسْوَاسِ ٱلْخَنَّاسِ ﴿4﴾

ٱلَّذِى يُوَسْوِسُ فِى صُدُورِ ٱلنَّاسِ ﴿5﴾

مِنَ ٱلْجِنَّةِ وَٱلنَّاسِ ﴿6﴾

11

Bismi Allahi alrrahmani alrraheemi

1 Qul a'oothu birabbi alnnasi

2 Maliki alnnasi

3 Ilahi alnnasi

4 Min sharri alwaswasi alkhannasi

5 Allathee yuwaswisu fee sudoori alnnasi

6 Mina aljinnati wa**al**nnasi

In the name of Allah, the Gracious, the Merciful

1 Say, "I seek refuge in the Lord of mankind.

2 The King of mankind.

3 The God of mankind.

4 From the evil of the sneaky whisperer.

5 Who whispers into the hearts of people.

6 From among jinn and among people."

12

سُورَةُ الفَلَقِ

AL-FALAQ

DAYBREAK

بِسْمِ اللَّهِ الرَّحْمَٰنِ الرَّحِيمِ

قُلْ أَعُوذُ بِرَبِّ الْفَلَقِ **1** مِن شَرِّ مَا خَلَقَ **2**

وَمِن شَرِّ غَاسِقٍ إِذَا وَقَبَ **3**

وَمِن شَرِّ النَّفَّاثَاتِ فِى الْعُقَدِ **4**

وَمِن شَرِّ حَاسِدٍ إِذَا حَسَدَ **5**

13

Bismi Allahi alrrahmani alrraheemi

1. Qul a'oothu birabbi alfalaqi

2. Min sharri ma khalaqa

3. Wamin sharri ghasiqin itha waqaba

4. Wamin sharri alnnaffathati fee al'uqadi

5. Wamin sharri hasidin itha hasada

In the name of Allah,
the Gracious, the Merciful

1. Say, "I take refuge with the Lord of Daybreak.

2. From the evil of what He created.

3. And from the evil of the darkness as it gathers.

4. And from the evil of those who practice sorcery.

5. And from the evil of an envious when he envies."

14

سُورَةُ القَدْرِ

AL-QADR

DECREE

بِسْمِ اللَّهِ الرَّحْمَٰنِ الرَّحِيمِ

وَمَآ أَدْرَىٰكَ مَا لَيْلَةُ ٱلْقَدْرِ ﴿2﴾ إِنَّآ أَنزَلْنَٰهُ فِى لَيْلَةِ ٱلْقَدْرِ ﴿1﴾

لَيْلَةُ ٱلْقَدْرِ خَيْرٌ مِّنْ أَلْفِ شَهْرٍ ﴿3﴾

تَنَزَّلُ ٱلْمَلَٰٓئِكَةُ وَٱلرُّوحُ فِيهَا بِإِذْنِ رَبِّهِم مِّن كُلِّ أَمْرٍ ﴿4﴾

سَلَٰمٌ هِىَ حَتَّىٰ مَطْلَعِ ٱلْفَجْرِ ﴿5﴾

15

Bismi Allahi a**l**rra<u>h</u>m<u>a</u>ni a**l**rra<u>h</u>eem**i**

(1) Inn<u>a</u> anzaln<u>a</u>hu fee laylati alqadr**i**

(2) Wam<u>a</u> adr<u>a</u>ka m<u>a</u> laylatu alqadr**i**

(3) Laylatu alqadri khayrun min alfi shahr**in**

(4) Tanazzalu almala-ikatu wa**al**rroohu feeh<u>a</u> bi-i<u>th</u>ni rabbihim min kulli amr**in**

(5) Sal<u>a</u>mun hiya <u>h</u>att<u>a</u> ma<u>tl</u>a'i alfajr**i**

In the name of Allah,
the Gracious, the Merciful

1 We sent it down on the Night of Decree.

2 But what will convey to you what the Night of Decree is?

3 The Night of Decree is better than a thousand months.

4 In it descend the angels and the Spirit, by the leave of their Lord, with every command.

5 Peace it is; until the rise of dawn.

16

سُورَةُ قُرَيْشٍ

QURAYCH

QURAISH

بِسْمِ اللَّهِ الرَّحْمَنِ الرَّحِيمِ

لِإِيلَفِ قُرَيْشٍ ﴿1﴾ إِ لَفِهِمْ رِحْلَةَ الشِّتَاءِ وَالصَّيْفِ ﴿2﴾

فَلْيَعْبُدُوا رَبَّ هَذَا الْبَيْتِ ﴿3﴾

الَّذِي أَطْعَمَهُم مِّن جُوعٍ وَءَامَنَهُم مِّنْ خَوْفٍ ﴿4﴾

Bismi Allahi alrrahmani alrraheemi

(1) Li-eelafi qurayshin

(2) Eelafihim rihlata alshshita-i waalssayfi

(3) Falya'budoo rabba hatha albayti

(4) Allathee at'amahum min joo'in waamanahum min khawfin

*In the name of Allah,
the Gracious, the Merciful*

(1) For the security of Quraish.

(2) Their security during winter and summer journeys.

(3) Let them worship the Lord of this House.

(4) Who has fed them against hunger, and has secured them against fear.

18

سُورَةُ النَّصْرِ

AN-NASR

VICTORY

بِسْمِ ٱللَّهِ ٱلرَّحْمَٰنِ ٱلرَّحِيمِ

١ إِذَا جَاءَ نَصْرُ ٱللَّهِ وَٱلْفَتْحُ

٢ وَرَأَيْتَ ٱلنَّاسَ يَدْخُلُونَ فِي دِينِ ٱللَّهِ أَفْوَاجًا

٣ فَسَبِّحْ بِحَمْدِ رَبِّكَ وَٱسْتَغْفِرْهُ إِنَّهُ كَانَ تَوَّابًا

Bismi Allahi alrrahmani alrraheemi

1 Itha jaa nasru Allahi waalfathu

2 Waraayta alnnasa yadkhuloona
fee deeni Allahi afwajan

3 Fasabbih bihamdi rabbika waistaghfirhu
innahu kana tawwaban

In the name of Allah,
the Gracious, the Merciful

1 When there comes Allah's victory, and
conquest.

2 And you see the people entering Allah's
religion in multitudes.

3 Then celebrate the praise of your Lord, and
seek His forgiveness. He is the Accepter
of Repentance.

20

سُورَةُ الفِيلِ

AL-FIL

ELEPHANT

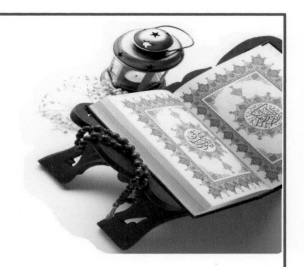

بِسْمِ اللَّهِ الرَّحْمَنِ الرَّحِيمِ

أَلَمْ تَرَ كَيْفَ فَعَلَ رَبُّكَ بِأَصْحَبِ الْفِيلِ **1**

أَلَمْ يَجْعَلْ كَيْدَهُمْ فِى تَضْلِيلٍ **2**

وَأَرْسَلَ عَلَيْهِمْ طَيْرًا أَبَابِيلَ **3**

تَرْمِيهِم بِحِجَارَةٍ مِّن سِجِّيلٍ **4**

فَجَعَلَهُمْ كَعَصْفٍ مَّأْكُولٍ **5**

21

Bismi Allahi alrrahmani alrraheemi

(1) Alam tara kayfa fa'ala rabbuka bi-as-habi alfeeli

(2) Alam yaj'al kaydahum fee tadleelin

(3) Waarsala 'alayhim tayran ababeela

(4) Tarmeehim bihijaratin min sijjeelin

(5) Faja'alahum ka'asfin ma/koolin

In the name of Allah, the Gracious, the Merciful

1 Have you not considered how your Lord dealt with the People of the Elephant?

2 Did He not make their plan go wrong?

3 He sent against them swarms of birds.

4 Throwing at them rocks of baked clay.

5 Leaving them like chewed-up leaves.

سُورَةُ الْعَصْرِ

AL-ASR

TIME

بِسْمِ ٱللَّهِ ٱلرَّحْمَٰنِ ٱلرَّحِيمِ

وَٱلْعَصْرِ ﴿١﴾ إِنَّ ٱلْإِنسَٰنَ لَفِى خُسْرٍ ﴿٢﴾

إِلَّا ٱلَّذِينَ ءَامَنُواْ وَعَمِلُواْ ٱلصَّٰلِحَٰتِ

وَتَوَاصَوْاْ بِٱلْحَقِّ وَتَوَاصَوْاْ بِٱلصَّبْرِ ﴿٣﴾

Bismi Allahi alrrahmani alrraheemi

1 Waal'asri

2 Inna al-insana lafee khusrin

3 Illa allatheena amanoo wa'amiloo alssalihati watawasaw bialhaqqi watawasaw bialssabri

In the name of Allah,
the Gracious, the Merciful

1 By Time.

2 The human being is in loss.

3 Except those who believe, and do good works, and encourage truth, and recommend patience.

سُورَةُ الكَافِرُونَ
AL-KAFIRUN
THE DISBELIEVERS

بِسْمِ اللَّهِ الرَّحْمَنِ الرَّحِيمِ

قُلْ يَاأَيُّهَا الْكَافِرُونَ ﴿1﴾ لَا أَعْبُدُ مَا تَعْبُدُونَ ﴿2﴾

وَلَا أَنتُمْ عَابِدُونَ مَا أَعْبُدُ ﴿3﴾ وَلَا أَنَا عَابِدٌ مَّا عَبَدتُّمْ ﴿4﴾

وَلَا أَنتُمْ عَابِدُونَ مَا أَعْبُدُ ﴿5﴾ لَكُمْ دِينُكُمْ وَلِيَ دِينِ ﴿6﴾

25

Bismi Allahi a**l**ra**h**m**a**ni a**l**rra**h**eem**i**

1. Qul y**a** ayyuh**a** alk**a**firoon**a**

2. L**a** a'budu m**a** ta'budoon**a**

3. Wal**a** antum '**a**bidoona m**a** a'bud**u**

4. Wal**a** ana '**a**bidun m**a** 'abadtum

5. Wal**a** antum '**a**bidoona m**a** a'bud**u**

6. Lakum deenukum waliya deen**i**

In the name of Allah,
the Gracious, the Merciful

1. Say, "O disbelievers.

2. I do not worship what you worship.

3. Nor do you worship what I worship.

4. Nor do I serve what you serve.

5. Nor do you serve what I serve.

6. You have your way, and I have my way."

سُورَةُ المَسَدِ

AL-MASAD

THORNS

بِسْمِ اللَّهِ الرَّحْمَٰنِ الرَّحِيمِ

1 تَبَّتْ يَدَآ أَبِى لَهَبٍ وَتَبَّ

2 مَآ أَغْنَىٰ عَنْهُ مَالُهُ وَمَا كَسَبَ

3 سَيَصْلَىٰ نَارًا ذَاتَ لَهَبٍ

4 وَٱمْرَأَتُهُ حَمَّالَةَ ٱلْحَطَبِ

5 فِى جِيدِهَا حَبْلٌ مِّن مَّسَدٍ

Bismi Allahi a**l**rra<u>h</u>m<u>a</u>ni a**l**rra<u>h</u>eem**i**

1. Tabbat yad<u>a</u> abee lahabin watab**ba**

2. M<u>a</u> aghn<u>a</u> 'anhu m<u>a</u>luhu wam<u>a</u> kasab**a**

3. Saya<u>sla</u> n<u>a</u>ran <u>th</u>ata lahab**in**

4. Wa**i**mraatuhu <u>h</u>amm<u>a</u>lata al<u>h</u>a<u>t</u>ab**i**

5. Fee jeediha <u>h</u>ablun min masad**in**

In the name of Allah,
the Gracious, the Merciful

1. Condemned are the hands of Abee Lahab, and he is condemned.

2. His wealth did not avail him, nor did what he acquired.

3. He will burn in a Flaming Fire.

4. And his wife—the firewood carrier.

5. Around her neck is a rope of thorns.

سُورَةُ التَّكَاثُر
AT-TAKATHOR
ABUNDANCE

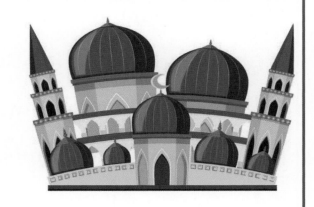

بِسْمِ اللَّهِ الرَّحْمَنِ الرَّحِيمِ

أَلْهَاكُمُ التَّكَاثُرُ ﴿1﴾ حَتَّى زُرْتُمُ الْمَقَابِرَ ﴿2﴾

كَلَّا سَوْفَ تَعْلَمُونَ ﴿3﴾ ثُمَّ كَلَّا سَوْفَ تَعْلَمُونَ ﴿4﴾

كَلَّا لَوْ تَعْلَمُونَ عِلْمَ الْيَقِينِ ﴿5﴾ لَتَرَوُنَّ الْجَحِيمَ ﴿6﴾

ثُمَّ لَتَرَوُنَّهَا عَيْنَ الْيَقِينِ ﴿7﴾ ثُمَّ لَتُسْأَلُنَّ يَوْمَئِذٍ عَنِ النَّعِيمِ ﴿8﴾

Bismi Allahi **a**lrra**h**m**a**ni alrra**h**eem**i**

(1) Al**h**akumu a**l**ttak**a**thur**u**

(2) **H**att**a** zurtumu almaq**a**bir**a**

(3) Kall**a** sawfa ta'lamoon**a**

(4) Thumma kall**a** sawfa ta'lamoon**a**

(5) Kall**a** law ta'lamoona 'ilma alyaqeen**i**

(6) Latarawunna alja**h**eem**a**

(7) Thumma latarawunnah**a** 'ayna alyaqeen**i**

(8) Thumma latus-alunna yawma-i**th**in 'ani a**l**nna'eem**i**

In the name of Allah,
the Gracious, the Merciful

(1) Abundance distracts you.

(2) Until you visit the graveyards.

(3) Indeed, you will know.

(4) Certainly, you will know.

(5) If you knew with knowledge of certainty.

(6) You would see the Inferno.

(7) Then you will see it with the eye of certainty.

(8) Then, on that Day, you will be questioned about the Bliss.

30

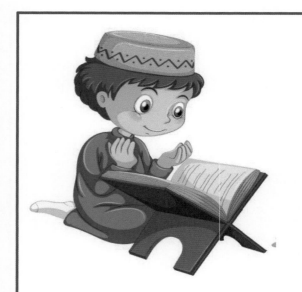

سُورَةُ الشَّرح

ASH-SHARH

THE SOOTHING

بِسْمِ اللَّهِ الرَّحْمَٰنِ الرَّحِيمِ

أَلَمْ نَشْرَحْ لَكَ صَدْرَكَ ﴿1﴾ وَوَضَعْنَا عَنكَ وِزْرَكَ ﴿2﴾

ٱلَّذِىٓ أَنقَضَ ظَهْرَكَ ﴿3﴾ وَرَفَعْنَا لَكَ ذِكْرَكَ ﴿4﴾

فَإِنَّ مَعَ ٱلْعُسْرِ يُسْرًا ﴿5﴾ إِنَّ مَعَ ٱلْعُسْرِ يُسْرًا ﴿6﴾

فَإِذَا فَرَغْتَ فَٱنصَبْ ﴿7﴾ وَإِلَىٰ رَبِّكَ فَٱرْغَب ﴿8﴾

31

Bismi Allahi alrrahmani alrraheemi

1. Alam nashrah laka sadraka

2. Wawada'na 'anka wizraka

3. Allathee anqada thahraka

4. Warafa'na laka thikraka

5. Fa-inna ma'a al'usri yusran

6. Inna ma'a al'usri yusran

7. Fa-itha faraghta fainsab

8. Wa-ila rabbika fairghab

In the name of Allah, the Gracious, the Merciful

1. Did We not soothe your heart?

2. And lift from you your burden.

3. Which weighed down your back?

4. And raised for you your reputation?

5. With hardship comes ease.

6. With hardship comes ease.

7. When your work is done, turn to devotion.

8. And to your Lord turn for everything.

سُورَةُ الْمَاعُونِ

AL-MA'UN

ASSISTANCE

بِسْمِ ٱللَّهِ ٱلرَّحْمَٰنِ ٱلرَّحِيمِ

أَرَءَيْتَ ٱلَّذِى يُكَذِّبُ بِٱلدِّينِ ﴿1﴾ فَذَٰلِكَ ٱلَّذِى يَدُعُّ ٱلْيَتِيمَ ﴿2﴾

وَلَا يَحُضُّ عَلَىٰ طَعَامِ ٱلْمِسْكِينِ ﴿3﴾ فَوَيْلٌ لِّلْمُصَلِّينَ ﴿4﴾

ٱلَّذِينَ هُمْ عَن صَلَاتِهِمْ سَاهُونَ ﴿5﴾ ٱلَّذِينَ هُمْ يُرَآءُونَ ﴿6﴾

وَيَمْنَعُونَ ٱلْمَاعُونَ ﴿7﴾

33

Bismi Allahi alrrahmani alrraheemi

1. Araayta allathee yukaththibu bialddeeni

2. Fathalika allathee yadu"u alyateema

3. Wala yahuddu 'ala ta'ami almiskeeni

4. Fawaylun lilmusalleena

5. Allatheena hum 'an salatihim sahoona

6. Allatheena hum yuraoona

7. Wayamna'oona alma'oona

In the name of Allah,
the Gracious, the Merciful

1. Have you considered him who denies the religion?

2. It is he who mistreats the orphan.

3. And does not encourage the feeding of the poor.

4. So woe to those who pray.

5. Those who are heedless of their prayers.

6. Those who put on the appearance.

7. And withhold the assistance.

34

سُورَةُ الهُمَزَةِ

AL-HOMAZAH

THE BACKBITER

بِسْمِ ٱللَّهِ ٱلرَّحْمَٰنِ ٱلرَّحِيمِ

١ ٱلَّذِى جَمَعَ مَالًا وَعَدَّدَهُ ٢ وَيْلٌ لِّكُلِّ هُمَزَةٍ لُّمَزَةٍ

٣ كَلَّا لَيُنۢبَذَنَّ فِى ٱلْحُطَمَةِ ٤ يَحْسَبُ أَنَّ مَالَهُۥ أَخْلَدَهُ

٥ نَارُ ٱللَّهِ ٱلْمُوقَدَةُ ٦ وَمَآ أَدْرَىٰكَ مَا ٱلْحُطَمَةُ

٧ ٱلَّتِى تَطَّلِعُ عَلَى ٱلْأَفْـِٔدَةِ ٨ إِنَّهَا عَلَيْهِم مُّؤْصَدَةٌ

٩ فِى عَمَدٍ مُّمَدَّدَةٍ

Bismi Allahi alrrahmani alrraheemi

(1) Waylun likulli humazatin lumaza**tin**

(2) Allathee jama'a malan wa'addadah**u**

(3) Yahsabu anna malahu akhladah**u**

(4) Kalla layunbathanna fee alhutama**ti**

(5) Wama adraka ma alhutama**tu**

(6) Naru Allahi almooqada**tu**

(7) Allatee tattali'u 'ala al-af-ida**ti**

(8) Innaha 'alayhim mu/sada**tun**

(9) Fee 'amadin mumaddada**tin**

In the name of Allah,
the Gracious, the Merciful

1 Woe to every slanderer backbiter.

2 Who gathers wealth and counts it over.

3 Thinking that his wealth has made him immortal.

4 By no means. He will be thrown into the Crusher.

5 And what will make you realize what the Crusher is?

6 Allah's kindled Fire.

7 That laps to the hearts.

8 It closes in on them.

9 In extended columns.

DUA

رَبَّنَا آتِنَا فِي الدُّنْيَا حَسَنَةً وَفِي الْآخِرَةِ حَسَنَةً وَقِنَا عَذَابَ النَّارِ

"rabbana atina fee alddunya hasanatan wafee al-akhirati hasanatan waqina 'athaba alnnari"

"Our Lord, give us goodness in this world, and goodness in the Hereafter, and protect us from the torment of the Fire."

This book is intended for Muslim kids aged 7 years old and over.

It will helps them learning many short surahs and understanding their meaning

It contains 16 short surahs:

AL FATIHAH/THE OPENING

AL KAWTHAR / PLENTY

AL IKHLAS / MONOTHEISM

AN-NAS / MANKIND

AL FALAQ / DAYBREAK

AL QADR / DECREE

QURAYSH / QURAISH

AN-NASR / VICTORY

AL FIL /THE ELEPHANT

AL ASR / TIME

AL KAFIRUN / THE DISBELIEVERS

AL MASAD / THORNS

AT-TAKATHOR / ABUNDANCE

ASH-SHARH / THE SOOTHING

AL MA'UN / ASSISTANCE

AL HOMAZAH / THE BACKBITER

Each surah is written in Arabic language, in Arabic phonetics with Latin letters and at

the end in English translation.

For any suggestion contact us on: k.mhnitich@gmail.com

Printed in Great Britain
by Amazon